IMAGES
of America

FORT WORTH STOCKYARDS

This sign is located in Fort Worth's stockyards area at the southwest corner of North Main Street and Exchange Avenue. If the continental United States were divided exactly in half, that line is located at the 98th meridian. Fort Worth is near it, so locals claim that this city, with its stockyards, is where the West begins. This sign has a deeper meaning, as the arrow is pointing uphill to the entrepreneurs of West Exchange Avenue, in contrast to the actual stockyards and numerous businesses on East Exchange Avenue. (Courtesy author.)

ON THE COVER: The "Fort Worth Stock Yards Hotel and Exchange" was the first exchange building constructed at the stockyards, located north of downtown Fort Worth. The wooden, two-story building provided the setting for one of the early National Feeders and Breeders Shows. Judges examined these steers on a March morning in 1901. (Courtesy North Fort Worth Historical Society.)

IMAGES
of America

FORT WORTH
STOCKYARDS

J'Nell L. Pate

ARCADIA
PUBLISHING

Copyright © 2009 by J'Nell L. Pate
ISBN 978-0-7385-5860-8

Published by Arcadia Publishing
Charleston SC, Chicago IL, Portsmouth NH, San Francisco CA

Printed in the United States of America

Library of Congress Catalog Card Number: 2008932141

For all general information contact Arcadia Publishing at:
Telephone 843-853-2070
Fax 843-853-0044
E-mail sales@arcadiapublishing.com
For customer service and orders:
Toll-Free 1-888-313-2665

Visit us on the Internet at www.arcadiapublishing.com

To Kenneth,
my husband of 48 years, who listens to and encourages me

Contents

Acknowledgments 6

Introduction 7

1. Early Beginnings 9
2. Stock Show Fun 27
3. Booming Times with Livestock 49
4. Transitions 73
5. Booming Times with Tourists 91
6. Just Folks 113

Acknowledgments

Betty Shankle and Tom Kellam—archivists and senior librarians of the Genealogy, History, and Archives Unit at the Fort Worth Public Library—were helpful to me. Katie Wilson, who runs the Stockyards Preservation Foundation's Web site for the Fort Worth Stockyards National Historic District (www.fortworthstockyards.org) provided a lot of contemporary photographs. Billy Joe Gabriel, former publisher of the *Stockyards Gazette*, opened his file of pictures to me. Dalton Hoffman was very generous with his personal collection of Fort Worth Stockyards postcards and photographs. Mark McCafferty allowed me to copy pictures of his parents, Charlie and Sue. Joe Dulle generously supplied photographs.

After gaining permission from president Billy Bob Watt Jr., Shana Weaver, the Southwestern Exposition and Livestock Show and Rodeo publicist, sent me to the Fort Worth Museum of Science and History to see the collection of images taken from early shows that were then held in the stockyards. At that museum, research librarian and archivist Jane Dees assisted me in my search for stock show photographs. Cathy Spitzenberger, special collections library assistant at the University of Texas at Arlington library, steered me through their stockyards photographs.

Sarah Biles, museum administrator of the North Fort Worth Historical Society Museum in the stockyards, was very helpful to me as I kept dropping by, calling, and e-mailing her with questions. The historical society also provided many photographs. Freddie Vandergriff, a longtime friend of my husband and myself from Azle, Texas, helped this technologically challenged computer novice learn to use CDs to put photographs in the computer and then move them around.

Kristie Kelly, acquisitions editor for Arcadia Publishing, answered all my e-mails quickly and kindly, sort of holding my hand over the Internet through this entire process.

Thanks to all!

INTRODUCTION

The Fort Worth Stockyards holds a distinction that not too many of the once booming stockyards can claim: it created a city. Yes, Fort Worth began as a tiny fort in 1849, but the military moved away after four years, and the small settlement languished. Not until cattle started moving northward from South Texas nearly two decades later did the little community of about 20 cabins find a purpose. The two general stores anticipated the large herds that came through on what first was called the Great Trail or Texas Trail, until finally the name Chisholm Trail became permanent.

Prominent men, including Khleber Van Zandt, worked hard to get a railroad, a meatpacking plant, and stockyards. By the beginning of the 20th century, as many as 10 railroads came together in Fort Worth as they brought cattle, calves, hogs, sheep, horses, and mules to market at the Fort Worth Stockyards north of the city.

Hard work—and the offer for each to own one-third of the stockyards—persuaded the meatpacking companies of Philip Armour and Gustavus Swift to build modern slaughtering facilities in Fort Worth in 1902.

Publicity efforts of the stockyards' promotional director, Charles C. French, contributed greatly to the increased receipts. French traveled Texas by rail and buggy to visit farming and ranching areas, promoting the livestock show. The show itself began at the yards in 1896 through the participation of the North Texas Cattle Raisers Association, later called the Texas and Southwestern Cattle Raisers Association. French also visited farm families and persuaded fathers to help their youngsters join calf clubs, pig clubs, and similar forerunners of the 4-H movement to raise the animals and sell them at the Fort Worth Stockyards.

By 1915, when World War I was raging in Europe, soldiers in the uniforms of as many as 15 countries could be seen purchasing horses and mules for their armies and for food. The Fort Worth Stockyards became the largest horse and mule market in the country, which at this time meant it was also the largest in the world. A total of 3.5 million animals of all types arrived in 1917. Things slowed during the Depression, but the company did not let workers go, just shortened their hours. By the 1940s, the country was engrossed in World War II, and the stockyards were ready to serve the needs of the war effort. In 1944, the stockyards received over two million sheep and ranked as the largest sheep market in the world. That year, a record 5.25 million animals arrived; the record stands.

After the war, marketing started changing, and local auctions expanded to include country towns. By the 1950s, feedlots became a growing phenomenon, especially in Texas. Meatpackers began buying directly from the feedlots, bypassing the large stockyards. Stockyards all over the country began to lose sales. They tried to turn the trend around but could not. By the 1970s, even the big stockyards in Chicago and Kansas City began closing. Fort Worth held on until 1992.

As early as the mid-1970s, people in the North Side of Fort Worth realized the value of the stockyards to the area and wanted to preserve the buildings, even if the actual livestock sales ended. Fortunately, people of civic and historic mind-sets like Holt Hickman, Steve Murrin, Joe Dulle,

and others bought up property and began businesses in the area. Through the efforts of Charlie and Sue McCafferty and like-minded folks, the North Fort Worth Historical Society began in 1976 with the goal of preserving the area's history. From a little office in the southeast corner of the Cowtown Coliseum, volunteers greeted the few tourists that began arriving. Congressman Jim Wright helped acquire grants to redevelop the stockyards area. New businesses opened, including Billy Bob's Texas, the "largest honky-tonk in the world," proving that everything comes bigger in Texas.

All of their joint efforts brought the tremendous results that people see today when they visit the Fort Worth Stockyards National Historic District. Locals enjoy coming to special events, and tourists make it one of their choice destinations.

One

Early Beginnings

The tiny Fort Worth community of 20 houses and two general stores sat on a bluff overlooking the spot where two forks of the Trinity River merged. In the late 1860s and early 1870s, citizens welcomed cattle drives as they came northward on their way to Kansas markets. Local men wanted to develop a market in Fort Worth, but first they had to attract a railroad, which they did in 1876: the Texas and Pacific. This was the first of numerous beginnings for the town. However, before success smiled on the livestock market, many failures disappointed the hardworking men of Fort Worth.

Several local individuals tried to start a meatpacking plant and stockyards in the south part of downtown. Finally, locals started two companies north of town, calling them the Fort Worth Union Stock Yards (stockyards was expressed as two words, as was common at the time) and the Fort Worth Packing Company. In 1893, outside entrepreneurs Louville V. Niles and Greenlief W. Simpson, both meatpackers from Boston, bought in. They too struggled because of the nationwide financial chaos caused by the Panic of 1893. Not until 1902, when the two largest meatpacking firms in the nation, Armour and Swift, made a deal to buy two-thirds of the stockyards and existing packing company, did the Fort Worth market begin to do extremely well.

Beginning in 1867, cattlemen from as far south as San Antonio came northward through Fort Worth to bring their $4 cattle to a $40 market via the railroads crossing Kansas. The cattle bedded down north of town in the actual area that decades later would be the location of the Fort Worth Stockyards. Trail Drivers Park developed just east of the stockyards to honor the men who drove thousands of cattle on the Chisholm Trail. (Photograph by J'Nell Pate.)

This Texas Longhorn steer, which came to the Fort Worth Stockyards in 1907, had horns totaling 7 feet, 1 inch in length from tip to tip. When stockyard workers unloaded railroad cars, they often had to help a longhorn turn his or her head sideways in order to get the horns through the opening. The sharp points on the end of the horns made their job difficult. (Courtesy Robert and Barty Duncan.)

10

Fort Worth businessmen chartered a company in 1889 they called the Fort Worth Dressed Meat and Packing Company. They failed to raise enough money, so the next year, after raising $200,000, they reorganized as the Fort Worth Packing Company. Verner S. Wardlaw came to Fort Worth to oversee the construction of the five large stone buildings seen here. The Fort Worth Packing Company opened November 21, 1890. (Courtesy Genealogy, History, and Archives Unit, Fort Worth Public Library.)

These buildings comprise the Fort Worth Packing Company that opened in 1890 and operated until 1902, when Armour and Swift arrived to build plants. The brand new six-story plants represented the most modern meatpacking facilities in the United States at the time. Note that this view of the Fort Worth Packing Company was from the back, and the photograph before this one was from the front, as can be determined by the position of the three smoke stacks. (Courtesy Dalton Hoffman.)

This man holds his Black Angus steer in front of the intricate wooden gingerbread latticework and slender columns of the original Stock Yards Hotel and Exchange. The man illustrates the more formal dress preferred in those days: suit, white shirt, and bow tie. At least he preserved his western credentials by wearing boots and a cowboy hat. (Courtesy Genealogy, History, and Archives Unit, Fort Worth Public Library.)

This photograph of the original Fort Worth Stock Yards Hotel and Exchange Building is one of the oldest in existence, dating from the early 1890s. Greenlief W. Simpson and Louville V. Niles of Boston bought the locally financed stockyards and renamed it the Fort Worth Stock Yards. In 1902, new owners of the stockyards tore down the structure and constructed the present Livestock Exchange Building that opened in 1903. (Courtesy North Fort Worth Historical Society.)

The wooden Fort Worth Stock Yards Hotel and Exchange Building, which predates the existing stucco Livestock Exchange Building, represented a popular architectural construction of the time. The structure was surrounded by barbed wire, probably to hold in livestock like these white-faced cattle. (Courtesy Genealogy, History, and Archives Unit, Fort Worth Public Library.)

The special event that drew all these people to the wooden exchange building in the Fort Worth Stockyards must have occurred before 1902 because that year the hotel and exchange building was torn down to make room for the large Spanish-style stucco Livestock Exchange Building that still exists. Most likely the event was one of the early stock shows. (Courtesy Jimmie Farmer.)

This photograph, taken between 1899 and 1900, shows the beginning of an evolution in pen design. The little hut to the center right would allow a worker or commission man, who sold the animals, to duck in out of the rain. By the 1940s, each commission company had constructed little houses that let four or five men sit comfortably. (Courtesy Tarrant County College District, Northeast Campus, Heritage Room, Fort Worth, Texas.)

Col. Thomas Marion Thannisch bought a small lot on the northeast corner of North Main Street and Exchange Avenue in 1904. He cleared away trees and constructed this two-story building, completing it in 1906. He opened the Stock Yards Club Saloon and Billiards Parlor on the first floor and rented out furnished rooms upstairs. In 1913, he replaced the structure in the photograph with a three-story brick building and attached it to a previously constructed brick building already on the property. The combined building functions today as the exclusive Stockyards Hotel. (Courtesy Genealogy, History, and Archives Unit, Fort Worth Public Library.)

This is one of the earliest photographs of the present Live Stock Exchange Building that opened in 1903. When Armour and Swift together bought two-thirds of the Fort Worth Stockyards, the newly reorganized company tore down the original wooden exchange building and constructed this larger stucco building. (Courtesy J. W. Dunlop Collection, Special Collections, the University of Texas at Arlington Library, Arlington, Texas.)

A bit of time has elapsed since the previous photograph. The yard has been fenced, and grass and trees are growing on the large front lawn of the new livestock exchange. Perhaps the lady in the surrey has come to pick up her husband after his livestock dealing. Note that in those more formal times, all the men wore suits. (Courtesy North Fort Worth Historical Society.)

This Fort Worth Live Stock Commission Company office rented space in the new Live Stock Exchange Building. A commission company acted as a broker, selling clients' livestock for a small commission per animal. J. D. Farmer, who would eventually become mayor of North Fort Worth, is the man with the mustache on the left. He also later had his own commission company. (Courtesy Genealogy, History, and Archives Unit, Fort Worth Public Library.)

BIRD'S-EYE VIEW OF PACKING HOUSES AND STOCK YARDS AT FORT WORTH, TEXAS.

Although many people walked, Exchange Avenue even looked busy during horse-and-buggy days. This scene occurred after 1903, when the new stucco Live Stock Exchange Building opened, but before 1911, when the wooden Horse and Mule Barns on the right burned. In 1912, the company constructed modern (for that period) brick structures for the horse and mule trade. Those buildings still stand. (Courtesy Genealogy, History, and Archives Unit, Fort Worth Public Library.)

These horse-drawn carts are on East Exchange Avenue. Not shown in the photograph is the exchange building just west of the livestock pens. Armour and Company bragged that the sign on the West Side of their plant was the largest sign in the state. It stretched 400 feet long and 80 feet high. (Courtesy Tarrant County College District, Northeast Campus, Heritage Room, Fort Worth, Texas.)

Local deliveries of processed Armour beef, ham, or lamb in 1905 would be by horse-drawn wagons such as this one. The curved roadway that goes up the hill east of the end of Exchange Avenue leads to the Armour office building and plant, as well as the Swift complex. The street today, leading to Packers Avenue, is one-way, opposite from the direction the horses and wagon are facing in the photograph. (Courtesy North Fort Worth Historical Society.)

The office building of Armour and Company was built somewhat similarly to that of the Swift building. These two meatpacking giants constructed their buildings at the same time in 1902. While the latter stands today, the Armour building no longer exists. Automobiles from the 1920s date the photograph. (Courtesy Dalton Hoffman.)

These railroad tracks in front of the Swift and Company complex received carloads of animals each day by rail, as well as workers arriving on the three streetcars shown. Armour and Swift purchased the largest percentage of the animals that came to the Fort Worth Stockyards, but not all of them. (Courtesy North Fort Worth Historical Society.)

Located due east and up the hill from the Fort Worth Stockyards complex are the remains of Armour and Swift's meatpacking plants, constructed in 1902. Representatives of the two plants relied on the luck of the draw to select a site for their buildings. Armour drew a 22-acre site just north of Swift's identical acreage. White letters on the ground spell out the companies, although only Swift's former office building and the shell of a burned building remain. (Photograph by J'Nell Pate.)

The Swift and Company two-story office building, surrounded by its meatpacking and refrigeration factories, faced its rival office of Armour and Company for six decades. The office building survived when a fire destroyed the closed Swift packing facilities on May 30, 1975. (Courtesy Tarrant County College District, Northeast Campus, Heritage Room, Fort Worth, Texas.)

This photograph of a National Feeders and Breeders Show was taken sometime after the opening of the Live Stock Exchange Building (1903) and before the coliseum was constructed (1908). Note the windmill demonstration at the center of the picture. The building to the left of the exchange was torn down after the coliseum was constructed. (Courtesy Dalton Hoffman.)

Trees and crowds feature more prominently in this photograph than the large Live Stock Exchange Building behind them. Only the two cupolas can be seen through the trees. The company whose sign shows prominently at right is Armour and Company, located east of the exchange building. The crowd at the stockyards is comprised totally of men mostly wearing white shirts, some even with ties. Hats apparently were fashionable too. (Courtesy Genealogy, History, and Archives Unit, Fort Worth Public Library.)

The sign on the side of this Armour and Company wagon touts "Star Hams and Bacon." In the early years at the Fort Worth Stockyards, the Armour and Swift meatpacking companies stressed pork products and wanted three times as many hogs as cattle. This was the situation at the stockyards and meatpacking facilities in the Midwest and East because people ate more pork than beef in those days. Apparently they forgot that Texas was cattle country, not hog country. Even so, a great deal of publicity somewhat increased hog production. (Courtesy North Fort Worth Historical Society.)

This 1922 photograph gives a broad view of East Exchange Avenue that includes (from left to right) the well-landscaped coliseum, called the North Side Coliseum in the early days; the Livestock Exchange Building; and Armour and Company on the far right. (The industry finally began spelling livestock as one word by this time.) This view gives almost the entire scope of the North Side of East Exchange Avenue, which comprised the Fort Worth Stockyards complex. Facing

these buildings on the south side of the East Exchange Avenue, but not shown here, would be the 10-year-old brick Horse and Mule Barns with a wide alley between two buildings, the covered hog pens to the east of the mule barns, the sheep pens east of that, railroad tracks, and then the Swift and Company complex facing Armour. (Courtesy North Fort Worth Historical Society.)

This vehicle looks more like an early-day bus, or jitney, rather than a pickup truck. This makeshift truck, however, carried several Berliner and Thompson calves to market at the Fort Worth Stockyards in 1914. The sides of the truck appear to be either chain or mesh, once perhaps fencing material. (Courtesy Fort Worth Museum of Science and History, Fort Worth Stock Show Collection.)

Here cattle mill around in a set of pens between the east side of the Livestock Exchange Building (visible at the back of this photograph) and the Armour and Swift meatpacking plants (out of sight) to the east. The function of the cloth seen on the ground in this photograph is unknown. (Courtesy Fort Worth Museum of Science and History, Fort Worth Stock Show Collection.)

While awaiting sale, these cattle were fed and watered at the Fort Worth Stockyards. A fact not known to many is that the Fort Worth Stockyards never owned any animals. Producers brought their livestock to market, commission companies handled the sale, and the buyer took possession. The stockyards simply provided the facilities for those sales to take place. The two meatpacking plants, Armour and Swift, purchased most of the animals brought to the stockyards. Some dealers bought cattle to place on feed and resell later. (Courtesy Fort Worth Museum of Science and History, Fort Worth Stock Show Collection.)

The view here is west, with East Exchange Avenue on the right side of the photograph. Construction is under way for the new brick Horse and Mule Barns after the 1911 fire. Numerous houses in the background testify to the rapid growth of North Fort Worth after the meatpackers arrived at the stockyards in 1902. The Horse and Mule Barns constructed in 1912 still stand. A Texas Cowboy Hall of Fame is located in a part of the Horse and Mule Barns in the 21st century. (Courtesy Fort Worth Museum of Science and History, Fort Worth Stock Show Collection.)

Two

STOCK SHOW FUN

The stock show, once supported by the Fort Worth Stockyards but now a separate entity, is Fort Worth's largest and most celebrated annual event, bringing in more than $100 million annually to the local economy. It hosts a 24-day run each January that stretches into the first week of February. The show began in the stockyards on a snowy March day in 1896 when ranchers brought their cattle and lined them up on the banks of Marine Creek. Promoters worried that the bad weather would ruin the show and dampen any enthusiasm for future livestock events. Stockyards promotional agent Charles C. French and Charles McFarland, a rancher near Weatherford and member of the North Texas Cattle Raisers Association, brainstormed the idea of a stock show during a conversation on McFarland's ranch. Although no show was held the next year in 1897, the event resumed in March 1898 and continued each year at the Fort Worth Stockyards until 1942, when a flood left a great deal of silt and sand on the floor of the coliseum. In 1943, during World War II, gasoline rationing and the use of the livestock exhibits building (now Billy Bob's Texas night club) for airplane assembly caused the show to be cancelled. The following year, the stock show moved to the new Will Rogers Memorial Complex on the West Side of Fort Worth and enjoyed larger crowds than they had previously in the stockyards. Earlier in the 20th century, the show had become independent and did not need financial support from the Fort Worth Stockyards, which originally had been the case. Motivated by the increased attendance, stock show promoters chose to remain on the West Side, and North Siders could not do anything about it. In response, the Fort Worth Stockyards National Historic District created its own show in the 1970s and presents a rodeo every Friday and Saturday night.

Contradicting the common assumption that all cowboys or livestock workers wore white hats, most of the handlers of these Shorthorn cattle are wearing caps. The men are participating in Shorthorn judging at one of the early National Feeders and Breeders shows, the forerunner of the present Southwestern Exposition and Livestock Show and Rodeo. (Courtesy Genealogy, History, and Archives Unit, Fort Worth Public Library.)

This bronze life-size statue of Quanah Parker, a Comanche chief, stands in front of the Hyatt Regency Hotel in the Fort Worth Stockyards. Called the "last great chief of the Comanches," Quanah visited Fort Worth to ride in the Grand Entry of the National Feeders and Breeders Show in 1907. (Photograph by J'Nell Pate.)

The coliseum opened in 1908 due west of the Livestock Exchange Building. This photograph shows a coliseum so new that landscaping had not yet been added. The coliseum housed the National Feeders and Breeders Show each year, known after the 1917 show as the Southwestern Exposition and Fat Stock Show and Rodeo. The Stockyards Championship Rodeos—rodeos not associated with the annual Fort Worth stock show—still take place in the Cowtown Coliseum each Friday and Saturday night. (Courtesy Dalton Hoffman.)

The Fort Worth Stockyards Company built the Cowtown Coliseum especially for the National Feeders and Breeders Show, but the "Main Entrance" arch was the doorway for all coliseum functions. The arch no longer exists. (Courtesy Dalton Hoffman.)

Presenting the colors on horseback at the beginning of the rodeo became an event that provided both pageantry and patriotism. Riders still seek out the honor of participating in this event. (Courtesy Fort Worth Museum of Science and History, Fort Worth Stock Show Collection.)

A cattle judging took place inside the brand new North Side Coliseum in 1908 at the National Feeders and Breeders Show. Few spectators sat in the stands, but a large number of participants and onlookers gathered on the floor. Suits, ties, and dress hats were the common mode of men's dress at a stock show in 1908. Jeans, colorful shirts, and cowboy hats would be a standard uniform a century later. (Courtesy Fort Worth Museum of Science and History, Fort Worth Stock Show Collection.)

This "posing" horse represented the Hook and Wood entry (probably the name of the farm or partnership) in the fat stock show. In the earlier days, before additional stock exhibit facilities were constructed, some judging events, or at least the photographs of them, occurred outside. The Livestock Exchange Building stands in the background. (Courtesy Fort Worth Museum of Science and History, Fort Worth Stock Show Collection.)

Behind this 1910 Feeders and Breeders Champion Stud of Show is a rare view of one of the wooden Horse and Mule Barns that burned down the following year. Brick buildings constructed in 1912 are still in use at the stockyards, but for purposes other than housing horses and mules. (Courtesy Fort Worth Museum of Science and History, Fort Worth Stock Show Collection.)

The driver in this photograph is showing Loula Hary's undefeated harness horse in the stock show competition. The building seen in the background is the North Side Coliseum, on its east side. In later years, the name became Cowtown Coliseum. From 1896 to 1942, with only one year missing, the stock shows were held at the Fort Worth Stockyards. (Courtesy Fort Worth Museum of Science and History, Fort Worth Stock Show Collection.)

The youngster in the light-colored suit holds his winner's cup because his litter of pigs won the prize at the stock show. Possibly he was a member of one of the pig clubs that stockyards promotional agent Charles C. French originated throughout Texas. The two-story building in the background to the right is the Armour and Company office building, which no longer exists. (Courtesy Fort Worth Museum of Science and History, Fort Worth Stock Show Collection.)

Breeders showed these Aberdeen Angus cows and calf on March 11–18, 1916, at the National Feeders and Breeders Show. G. F. Cowden and Son of Midland and Odessa, Texas, owned the cattle. (Courtesy Dalton Hoffman.)

This Polled Hereford steer was the winner one year at stock show. "Polled" means that the animal has no horns and is considered a separate breed with a special organization and judging. When competitors came to the Fort Worth Stockyards for the annual judging, they also took in the carnival rides, located in Mule Alley between the two large Horse and Mule Barns, and saw the rodeo in the coliseum. (Courtesy Fort Worth Museum of Science and History, Fort Worth Stock Show Collection.)

Looking a bit lonely in this pen is the champion single barrow of a National Feeders and Breeders Show from the first decade of the 20th century. Because the hog and sheep pens were located due east of the Horse and Mule Barns, the buildings in the background are most likely the wooden barns that burned in 1911. (Courtesy Fort Worth Museum of Science and History, Fort Worth Stock Show Collection.)

How handlers got their prize rooster to stand on the end of a barrel and pose for a photograph, only they knew. The National Feeders and Breeders Show—or Southwestern Exposition and Fat Stock Show and Rodeo—allowed judging of fowl, as well as hogs, sheep, goats, cattle, calves, and horses. (Courtesy Fort Worth Museum of Science and History, Fort Worth Stock Show Collection.)

This is the champion drake one year at the Stock Show. The judging of all types of animals at the stock show each year gave youngsters an important arena, besides the state fair each October in Dallas, in which to enter their animals. (Courtesy Fort Worth Museum of Science and History, Fort Worth Stock Show Collection.)

The champion rooster and champion hen pictured here are in two separate photographs placed together to save space. Probably the two would have been looking at each other instead of the camera if they had been on barrels this close together. (Courtesy Fort Worth Museum of Science and History, Fort Worth Stock Show Collection.)

Some controversy exists as to whether the first indoor rodeo in the coliseum took place in 1917 or 1918. A transition from "shows or performances" to competitive contests for money, or "rodeos," occurred in those years. While a contest did take place in 1917, it was not until after the 1917 show, getting ready for 1918, that the name changed to the Southwestern Exposition and Fat Stock Show and Rodeo, the latter term coined especially to describe a competitive event. (Courtesy Joseph Weisberg.)

The very first competition known as a rodeo taking place indoors occurred in 1918 at the 10-year-old North Side Coliseum during the annual stock show and drew this large crowd. Promoters even changed the name from the National Feeders and Breeders Show to the Southwestern Exposition and Fat Stock Show and Rodeo to acknowledge the importance of the event. (Courtesy Fort Worth Museum of Science and History, Fort Worth Stock Show Collection.)

This bronze statue of Bill Pickett, the African American cowboy who began the rodeo sport of bulldogging, or grounding a steer by its horns, is located in front of the Cowtown Coliseum near the two towers that mark the entrance into Rodeo Plaza. Pickett would literally bite the lip of the steer to distract it enough for him to twist its head around and make the animal fall down, its legs stretched straight out in front. Pickett became the first African American cowboy to be inducted into the National Cowboy Hall of Fame in Oklahoma City. (Photograph by J'Nell Pate.)

Scattered in sidewalks all over the stockyards are these "Texas Trail of Fame" medallions. Bill Pickett deserves his for his invention of the rodeo sport of bulldogging. He performed the action as a stunt in a traveling Wild West show for many years. (Photograph by J'Nell Pate.)

Kirmis Queen Pansy Walker reigned during the stock show on March 10, 1928. "Kirmis" is a Dutch term derived from the words "kerk" (church) and "mis" (mass) and was a celebration held on the anniversary of the founding of a church. An annual festival featured feasting, dancing, and sports. Fort Worthians held a Kirmis each year during the stock show and chose a queen. (Courtesy Fort Worth Museum of Science and History, Fort Worth Stock Show Collection.)

Colorful annual programs of the fat stock show, as locals called it, became collector's items. Cowgirls competed in barrel races in the annual rodeo, leaving the bull riding, bronc riding, and bulldogging to the cowboys. All participants were free to ride in a Grand Entry before each show or competition got under way. The events took place in the coliseum, located directly to the west of the Livestock Exchange Building. (Courtesy Genealogy, History, and Archives Unit, Fort Worth Public Library.)

38

The wide alley between the Horse and Mule Barns provided an excellent site for the stock show Midway in March 1930 at the stockyards. The Midway, with its booths and rides, was thus located directly across Exchange Avenue from the coliseum where the rodeo events took place. (Courtesy Genealogy, History, and Archives Unit, Fox Photograph Collection, Fort Worth Public Library.)

Guys on stilts certainly can attract a lot of attention in a parade. Each year, at the beginning of the stock show, sponsors organized a parade in downtown Fort Worth to persuade Fort Worthians of the fun they could have at the annual stock show and rodeo. Apparently, anybody who wanted to be in this parade on March 13, 1936, could do so. The wagon in front of the man on stilts was sponsored by the local chapter of the Daughters of the Republic of Texas. (Courtesy Genealogy, History, and Archives Unit, Fox Photograph Collection, Fort Worth Public Library.)

Man and animal are nearly indistinguishable in this rodeo competition event, called "bulldogging." This cowboy jumped off a horse to grab the steer by his head and horns with the intention of making it lie on its side, legs straight out in front. The cowboy who performed this feat in the fewest number of seconds would win. (Courtesy Genealogy, History, and Archives Unit, Fox Photograph Collection, Fort Worth Public Library.)

One wonders where the ladies were seated on this day in March 1937 when the lineup of men in hats watched the horses perform at this rodeo. The coliseum, constructed in 1908 adjacent to the Livestock Exchange Building, provided the setting for the Southwestern Exposition and Fat Stock Show and Rodeo that was held annually. (Courtesy Genealogy, History, and Archives Unit, Fox Photograph Collection, Fort Worth Public Library.)

Contestant No. 1 during the rodeo in March 1937 rode what the announcer called a "cork screw bucking horse" because of the animal's twisting and turning antics. Additional contestants squatted against the wall inside the ring, but were ready to jump and run if the unhappy bronc came near them. (Courtesy Genealogy, History, and Archives Unit, Fox Photograph Collection, Fort Worth Public Library.)

Notice that the cowboy on the white bucking bronco is holding onto a rope around the horse with his right hand, and his left hand is free. The more he waves it up in the air and encourages the horse to keep bucking, the better his score will be. The man on the horse in the background is there to ride up quickly and help the rider dismount after his eight seconds on the horse. (Courtesy Genealogy, History, and Archives Unit, Fox Photograph Collection, Fort Worth Public Library.)

41

Excitement builds as Desolation, a well-known rodeo horse, comes out of chute No. 4 and begins his expected antics to rid himself of the unwanted cowboy on his back. Spectators get as close as they can to the action, including the little boy on his dad's shoulders to the right. (Courtesy Genealogy, History, and Archives Unit, Fox Photograph Collection, Fort Worth Public Library.)

A highlight of the school year for farm boys who were members of 4-H came in March, when lambs were judged at the fat stock show. In March 1939, these boys anxiously awaited the results and hoped their lamb would win. The 4-H Club movement grew out of the pig, calf, lamb, and other clubs that developed in the second decade of the 20th century. (Courtesy Genealogy, History, and Archives Unit, Fox Photograph Collection, Fort Worth Public Library.)

The sign on this horse-drawn surrey states, "On our way to swap this rig for an old used car at Ernest Allen." The longtime Fort Worth Chevrolet dealer advertised his business during the annual Southwestern Exposition and Fat Stock Show and Rodeo Parade in downtown Fort Worth. The photograph was taken in front of Haltom's Jewelers on Main Street. (Courtesy Genealogy, History, and Archives Unit, Fox Photograph Collection, Fort Worth Public Library.)

Future Farmers of America clubs enroll many rural 21st century youngsters, but even more participated in 1941. That year, they took part in Fort Worth's annual stock show parade to urge citizens to come out to the stock show and rodeo. Of course, friends, parents, and grandparents would attend the judging of their particular youngster's calf, pig, lamb, or other entry. (Courtesy Genealogy, History, and Archives Unit, Fox Photograph Collection, Fort Worth Public Library.)

Tired patrons rest a bit on opening day of the Southwestern Exposition and Fat Stock Show and Rodeo, March 8, 1941, in front of the Cowtown Coliseum. No one knew at the time that only one more show would be held in the stockyards the next year before organizers moved events across town to the West Side of Fort Worth in the new Will Rogers Memorial Center. (Courtesy Genealogy, History, and Archives Unit, Fox Photograph Collection, Fort Worth Public Library.)

Local Fort Worth folks enjoy dressing Western when they visit the stock show and rodeo each year. In this March 8, 1941, photograph, even the ladies made sure they had their boots and tailored Western outfits on when they came for the fun. Though Levis and other jeans dominate in the 21st century, boots were always correct. (Courtesy Genealogy, History, and Archives Unit, Fox Photograph Collection, Fort Worth Public Library.)

44

Youngsters liked the Midway, but their parents enjoyed the exhibits building, where various Western products dominated the booths. Enid Justin, whose family owned Justin Boots, started her own business, Nocona Boot Company, when her brothers moved the Justin company from Nocona to Fort Worth in 1925. She developed a multimillion-dollar business out of it. A stroke in 1981 caused her to sell to Justin Boots. She died in 1990 at age 96. (Courtesy Genealogy, History, and Archives Unit, Fox Photograph Collection, Fort Worth Public Library.)

Olsen-Stelzer Boot Company competed with the Nocona Boot Company from their shop in Henrietta, Texas, just 30 miles to the west of Nocona. Olsen-Stelzer also made saddles, as their booth at the March 1941 stock show reveals. Julius Stelzer, the former husband of Enid Justin, with partner Carl Olsen, who had long been in the boot business, created the Olsen-Stelzer Boot Company in 1934. Olsen-Stelzer, after being closed a short time in the 1980s, is again making boots in Henrietta. (Courtesy Genealogy, History, and Archives Unit, Fox Photograph Collection, Fort Worth Public Library.)

The Midway at the Southwestern Exposition and Fat Stock Show and Rodeo in March 1941 featured a large Ferris wheel and numerous advertisements from Fort Worth stores like Montgomery Wards, Fort Worth Poultry Egg Company, J. D. Spencer Hardware, Lovelace Grocery, and others. The Ferris wheel originated at the World's Columbian Exposition in Chicago in 1893. Today a Midway is not complete without one. (Courtesy Genealogy, History, and Archives Unit, Fox Photograph Collection, Fort Worth Public Library.)

A treat that youngsters anticipated each year at the stock show was the cotton candy stand, with its fluffy pink clouds of sweet, but messy, confection. When the boys here went home with sticky smudges on their clothes, their mothers probably rejoiced that the stock show came but once a year. However, the "pink stuff" was often sold at other Fort Worth events, such as the circus. (Courtesy Genealogy, History, and Archives Unit, Fox Photograph Collection, Fort Worth Public Library.)

A parade on the Midway during the 1941 stock show kept patrons entertained. Various high schools throughout Fort Worth took assigned turns providing music for the parade. If folks thought that the high school bands always had boys as drum majors back in 1941, they would be mistaken. This lively young person leading the band is the drum majorette. (Courtesy Genealogy, History, and Archives Unit, Fort Worth Public Library.)

This photograph shows the large, turnstile ticket booth for the Southwestern Exposition and Fat Stock Show and Rodeo in March 1942, the last year that the show was held in the stockyards. The ticket booth is still in use for other events at the Cowtown Coliseum, including the weekly rodeos every Friday and Saturday nights. In this picture, a fence keeps people off the grounds and acts as crowd control, sending them through the turnstile. From there, patrons can make their way to the coliseum's front door. (Courtesy North Fort Worth Historical Society.)

Not all rodeo acts are competitive events for cowboys. Sometimes folks just like to see a good show. The owners of these performing horses and the coliseum's record crowd enjoyed the festivities without knowing that it would be the last year the Southwestern Exposition and Fat Stock Show and Rodeo would be held at the stockyards on the North Side. World War II and a flood in the area necessitated a move across town. (Courtesy Genealogy, History, and Archives Unit, Fox Photograph Collection, Fort Worth Public Library.)

A ceremony on horseback called Posting the Colors opens each rodeo. This particular posting occurred in 1942 during the last year that the Southwestern Exposition and Fat Stock Show and Rodeo was held in the stockyards. It seems fitting that a photograph from the last year should also close this chapter about the exposition that first began on a snowy day in March 1896 in the Fort Worth Stockyards. The Southwestern Exposition and Fat Stock Show and Rodeo continued for 46 years at the stockyards before moving away. (Courtesy Genealogy, History, and Archives Unit, Fox Photograph Collection, Fort Worth Public Library.)

Three

BOOMING TIMES WITH LIVESTOCK

After their two large meatpacking firms, Armour and Swift, bought into the Fort Worth Stockyards Company, constructed their two modern meat processing plants, and cooperated in the building of the Livestock Exchange Building in 1903 and the North Side Coliseum in 1908, the only direction for Fort Worth's economy to go was up. Because the two meatpackers could purchase all of the animals that could be brought to the stockyards and pay producers promptly, business boomed. The Fort Worth Stockyards Company owned not only the yards and the buildings but a bank, a town site company, a newspaper, a cattle loan company, and the Belt Railroad that brought the cattle to the yards. The company sold lots to businesses or families who flocked to the area.

Luckily for Fort Worth and the stockyards, their expansion came during one of the decades of the "new immigration," a time when more immigrants were able to come to America because of cheaper shipping fares and Ellis Island to welcome them in New York. They came from Central or Eastern Europe: Poles, Greeks, Italians, Serbs, Russians, Czechs, and others who traveled directly to the North Side of Fort Worth and the stockyards area to find work. Most large cities experienced such growth.

By the end of the first decade of the 20th century, the population of Fort Worth had tripled from 25,000 to 75,000. Part of this boom came when Fort Worth annexed North Fort Worth, the area north of downtown near the stockyards. Fort Worth's founding fathers left the actual stockyards complex out of the city limits (and its tax base) with the hope of attracting more industry. Unfortunately, not enough industry developed, so the city of Fort Worth made an attempt to annex the stockyards in 1911. To block it, Fort Worth Stockyards officials incorporated their own city, creating Niles City. It was called the "richest little city in the U.S." because of the $30-million business within its limits.

The "Wall Street of the West" is what folks proudly called East Exchange Avenue, primarily because of the Fort Worth Livestock Exchange (or the stockyards itself). A livestock exchange had the job of policing its own market and regulating the various groups who did business there. Unfortunately, the Texas legislature outlawed the exchange in 1907 in some antitrust legislation, but the stockyards continued to provide tremendous economic progress for Fort Worth and West Texas through activities that took place in the Livestock Exchange Building. This Texas Historical Marker acknowledges their achievement. (Photograph by J'Nell Pate.)

These pens are located behind and northeast of the coliseum building and directly behind the Livestock Exchange Building. Longhorn characteristics are still visible in the cattle. Note the boy on the right with a cap and his pant legs tucked in. Stockyards workers did not necessarily dress as cowboys. Actually, with all the muck the workers had to step in, this young man was wise to tuck in his pants. (Courtesy Dalton Hoffman.)

The man on the left with the Hoss Cartwright–type hat watches cattle being taken from a pen to be driven down the alley to a weigh scale. The alley was paved with bricks made in Thurber, a coal-mining community about 80 miles due west of Fort Worth. Many new immigrants worked in the coal mines, and some of them came to Fort Worth to work in the stockyards after the mines closed. (Courtesy Dalton Hoffman.)

Hundreds of small wooden pens stretched northward behind the Livestock Exchange Building. Note the wooden, raised ramp that allowed stockyards workers to walk above the pens to the exchange building at the back of the photograph. Workers drove cattle to weigh stations using the alley to the right. (Courtesy Fort Worth Museum of Science and History, Fort Worth Stock Show Collection.)

These full pens in front of Armour and Company are a testimony to the booming business at the Fort Worth Stockyards in the early part of the 20th century. Actually, the pens are located due east of the Livestock Exchange Building. Railroad tracks lie between the pens and the Armour office building and meatpacking facilities. The office building of Swift may be seen at the right. (Courtesy Dalton Hoffman.)

Swift and Company purchased this pen of five hogs. In the early 1900s, families ate more pork than beef. Both Armour and Swift were accustomed to more hog receipts in their Midwestern packing plants and were disappointed at the fewer loads of pigs in Fort Worth. Receipts of cattle, and later sheep, predominated. (Courtesy Fort Worth Museum of Science and History, Fort Worth Stock Show Collection.)

Charles French served as the promotional agent for the stockyards and helped organize the first fat stock show there in 1896. In 1908, he launched a campaign to increase hog receipts by organizing boys' pig clubs all over Texas. Small-town businessmen would help a young man buy a sow, and the young man agreed to pay it off by selling two litters of pigs, when grown, at the Fort Worth Stockyards. (Photograph by J'Nell Pate.)

This picket fence and wooden building represented the local municipal government for Niles City, the "richest little city in the U.S." When wealth is calculated by income per capita, a tiny population with a huge industry equates to "richest." Although located adjacent to Fort Worth on the north, the stockyards incorporated their own city, first called North Fort Worth, and later Niles City after Fort Worth annexed North Fort Worth. It was named after Louville Niles, a Boston meatpacker who, with a partner, bought out the local yards in 1893. (Courtesy Genealogy, History, and Archives Unit, Fort Worth Public Library.)

Niles City Town Hall stood at 2354 Decatur Avenue and served as the second building to house city offices. Fort Worth annexed an unwilling Niles City in 1922 after a court battle. (Courtesy North Fort Worth Historical Society.)

Although these men are in plain clothes, they are actually policemen. The Fort Worth Police Department was often called upon to protect the large numbers of people who attended stock shows. During a strike or two out in the yards, the police had to deal with mobs of strikebreakers who tried to prevent workers from arriving at the meatpacking plants. (Courtesy Fort Worth Museum of Science and History, Fort Worth Stock Show Collection.)

Owned by the Fort Worth Stockyards, the Stockyards National Bank advertised itself as the "clearing house for the great livestock market of the Southwest." The gate that says "Anchor Fence Co. Fort Worth" leads to the small building on the far right that housed the *Daily Livestock Reporter*, the newspaper owned by the stockyards company. This small building has since been torn down. (Courtesy Dalton Hoffman.)

Before this white stucco building (pictured here in the 1940s) became the North Fort Worth Bank in 1939, it was once the Stockyards National Bank, where a robbery occurred in 1930. A distraught man named Nathan Martin carried nitroglycerine into the building and demanded $10,000 from a teller. When policemen walked in the door, he dropped his weapon, killing himself and a clerk. In 1977, White and Fincher's Clothing Store took up residence. The bank vault is still in the store. (Courtesy Tarrant County College District, Northeast Campus, Heritage Room, Fort Worth, Texas.)

Guests at a livestock-oriented dinner about 1938 include, from left to right, (seated) A. A. Lund, general manager, Armour and Company; Charlie Daggett, Daggett Commission Company; Jim Farmer, Farmer Commission Company; and John Hall, general manager Swift and Company; (standing) Bert O'Connell, head cattle buyer, Swift and Company; George Scaling, head cattle buyer, Armour and Company; and Charlie Breedlove, Breedlove Commission Company. (Courtesy Burt Weeman.)

This is a photograph of Bert O'Connell, head cattle buyer for Swift and Company from 1910 to 1940. A cattle or hog buyer could look at an animal and estimate within a few pounds how much the carcass would weigh when "dressed out," i.e. been through the meatpacking process. If the buyer missed his estimate too many times, the bosses at Armour or Swift would replace him with someone who could be a bit more accurate. Obviously, O'Connell must have been excellent at guessing weight. (Courtesy Burt Weeman.)

In this 1930s aerial view of the stockyards, one can clearly see Armour and Company to the left. The buildings on the right make up the Swift and Company complex. In the foreground, rail lines separate the buildings from covered hog and sheep pens. The livestock ramp on the right crosses the railroad tracks over to Swift. (Courtesy Tarrant County College District, Northeast Campus, Heritage Room, Fort Worth, Texas.)

This July 1935 photograph shows a view of the stockyards looking south from Twenty-eighth Street. The back of the coliseum can be seen in the background, center right, with the Livestock Exchange Building to its left. The large building in the foreground surrounded by trains and railroad tracks was a railroad shop. Because of the stockyards, as many as 10 railroads built tracks to Fort Worth by the early 20th century. (Courtesy, *Fort Worth Star-Telegram* Collection, Special Collections, the University of Texas at Arlington Library, Arlington, Texas.)

This large, tower-like entrance leads to Mule Alley—the wide space between two large brick Horse and Mule Barns. When constructed in 1912 to replace wooden barns that had burned the year before, the new barns were state of the art. Even the hint of smoke would set doors clanging together to keep a fire from spreading. The barns still stand in the stockyards. (Courtesy, *Fort Worth Star-Telegram* Collection, Special Collections, the University of Texas at Arlington Library, Arlington, Texas.)

The stockyards supplied horses and mules for the U.S. Army and its cavalry units. By World War I, local yards provided so many horses and mules to Europe that in 1915 it became the largest market for such animals in the world. This photograph, however, predates World War I. (Courtesy Fort Worth Museum of Science and History, Fort Worth Stock Show Collection.)

Believe it or not, mules were a popular animal over a century ago. Mule trains carried merchandise and made good pack animals for the army, too. The Fort Worth Stockyards handled mules and horses, but cowboys called the space between the two Horse and Mule Barns "Mule Alley." Commission agents like the Ross Brothers Horse and Mule Company, shown here, sold the animals for others for a commission. (Courtesy North Fort Worth Historical Society.)

The man seen here in the chair working at scale No. 1 is Charlie McCafferty Sr. Several animals, called a draft, could be weighed at once, and were driven onto the scale. The commission agent called out the purchaser and the price per pound as the weigh master wrote the information on the scale ticket, weighed the livestock, and stamped the weight on the ticket. Once the animals stepped off the scale, they belonged to the new buyer. (Courtesy North Fort Worth Historical Society.)

This photograph dates from 1961, when many sheep still arrived at the stockyards. Because sheep will follow a leader, a goat was used to lead them over the wooden ramp to the meatpacking plant. Consequently, this animal was called a Judas goat. In 1944, when over two million sheep came through, the Fort Worth Stockyards reigned as the "largest sheep market in the world." (Courtesy *Fort Worth Star-Telegram* Collection, Special Collections, the University of Texas at Arlington Library, Arlington, Texas.)

Four head buyers for Swift and Company about 1945 posed in front of full pens at the Fort Worth Stockyards in this photograph. From left to right are C. L. Hissrich, head calf buyer; Harry Butz, head sheep buyer; Claude Spurlock, head hog buyer; and Roy Weeman, head cattle buyer. Men like this worked their way up with the company and generally remained on the job for 30 to 40 years. (Courtesy Burt Weeman.)

The little house up on the pens belongs to John Clay and Company, commission agents for cattle, sheep, and hogs. With several branches nationally, this commission company was one of the first at the Fort Worth Stockyards. Walkways allowed workers to travel around the pens, to and from these on-the-scene "offices." The man in the foreground to the right is Milt Hogan, Armour and Company's head cattle buyer. (Courtesy Mr. and Mrs. Hilton Kutch.)

After a stockyards fire on August 21, 1947, the Swift cattle chute was left hanging and had to be rebuilt. Animals to be slaughtered arrived through a similar chute on the sixth floor, were killed, and by the time they reached the first floor, were ready to be shipped out by rail. (Courtesy *Fort Worth Star-Telegram* Collection, Special Collections, the University of Texas at Arlington Library, Arlington, Texas.)

Following the close of World War II, most animals arrived not by rail, but by trucks like these lined up on Twenty-eighth Street on October 17, 1946. By 10:00 that morning, 1,121 trucks had unloaded. The boy on the horse must have decided that he wanted his picture in the *Fort Worth Star-Telegram* that day. (Courtesy *Fort Worth Star-Telegram* Collection, Special Collections, the University of Texas at Arlington Library, Arlington, Texas.)

A load of Hereford cattle arrived at the docks on the north end of the stockyards on January 28, 1946. The war was over, gas rationing and price controls lifted, and hundreds of farmers and ranchers began bringing their animals to market. Huge runs became commonplace. (Courtesy *Fort Worth Star-Telegram* Collection, Special Collections, the University of Texas at Arlington Library, Arlington, Texas.)

By 9:30 a.m. on the morning of September 4, 1951, a total of 9,536 cattle and calves had been unloaded at the Fort Worth Stockyards, representing the largest cattle run since the fall of 1949. Most likely, the Labor Day weekend allowed operators who had other jobs the time to bring a cow or two into the stockyards for sale. These operators turned their animals over to their commission agent, went home, and waited for a check to arrive by mail. (Courtesy *Fort Worth Star-Telegram* Collection, Special Collections, the University of Texas at Arlington Library, Arlington, Texas.)

Pickups are lined up to unload at the far north end of the stockyards on July 22, 1960. (Most small farmers loaded their animals into a pickup truck or trailer to bring them to market.) Already the Fort Worth Stockyards was competing for receipts with the smaller country auctions. Larger markets like Fort Worth had been regulated by price controls during the war, but smaller auctions escaped scrutiny. (Courtesy Fort Worth Museum of Science and History, Fort Worth Stock Show Collection.)

Al Donovan, who began working for Armour and Company in Kansas City, moved to Fort Worth in 1902 with a company that repaired railroad cars. In 1916, he became vice president and general manager of the Fort Worth Stockyards, holding the latter position until 1946 when he moved up to president. (Courtesy A. G. Donovan, Jr.)

This is a 1940s aerial view of the stockyards before the owners turned the front lawn of the Livestock Exchange Building into a parking lot. Mule Alley is visible at the left front of the photograph with the Horse and Mule Barns on each side. To the right and behind the coliseum and the Livestock Exchange Building, center left, are cattle pens with little commission company houses on top of them. (Courtesy Texas and Southwestern Cattle Raisers Association.)

The occasion for this photograph at the Daggett-Keen Commission Company office was the first-place carload of 40 steers at the Texas Hereford Association Stocker and Feeder Sale on May 11, 1956. The Waggoner estate of Vernon, Texas, showed the cattle, and the Farmer Commission Company represented them in the sale. Pictured from left to right are Henry Arledge, president of the Texas Hereford Association; judge A. H. Brackeen from Palo Pinto, Texas; John Biggs, manager of the Waggoner estate; Bill Pier, president of the Fort Worth Stockyards Company; and Tony Hazelwood, foreman on the Waggoner Ranch. (Courtesy Jimmie Farmer.)

Visible at the lower right corner of this panoramic photograph is the coliseum, covered pens behind, and the Livestock Exchange Building beside it. The Armour and Swift meatpacking plants are at the top of the photograph, east of the railroad tracks. This large industrial complex was located within about four miles of downtown Fort Worth. (Courtesy Dalton Hoffman.)

Apparently, someone looking southeast on the roof of the Livestock Exchange Building took this photograph of the Swift buildings. To the left of the two-story Swift office and building complex, the old Fort Worth Packing Company building stands, not yet demolished. Covered sheep pens are most prominent in the center. In the 21st century, Stockyards Station is located on the site of these former sheep pens. (Courtesy Dalton Hoffman.)

In this close-up of the Swift complex, viewers see the two-story, colonial-style office building with wraparound porches. Gustavus Swift founded the company in Chicago and pioneered the shipment of slaughtered beef in iced-down railroad cars even before refrigeration had been developed. (Courtesy Dalton Hoffman.)

This aerial view of the stockyards was taken January 4, 1946, and looks southward from north of the Twenty-eighth Street viaduct. Covered sheep and hog pens are at the top of the picture facing the Livestock Exchange Building and the coliseum. Top left, ramps over the railroad tracks connect packing plants to livestock pens. In later years, the yards grew so large that the company even constructed pens north of Twenty-eighth Street. (Courtesy Dalton Hoffman.)

Beautiful landscaping graced the front lawn of the Live Stock Exchange Building during the first half of the 20th century. In the 1950s, when officials believed that the space was needed for parking, they took out the entire front lawn. When renovation of the building and other improvements began to bring a trickle of tourists in the 1980s, the grass, trees, and flowers returned to enhance the appearance of the building. (Courtesy Dalton Hoffman.)

Note that most of the vehicles in the parking lot are cars, not pickups. Many of them belonged to commission men and other workers who had offices in the Exchange building. Farmers and ranchers delivered their animals at drop-off spots north of the pens. (Courtesy Fort Worth Museum of Science and History, Fort Worth Stock Show Collection.)

This photograph of the stockyards was taken in the 1950s, looking southeast. North Main Street runs through the lower half, and perpendicular to it on the left is Twenty-eighth Street. The coliseum and Livestock Exchange Building (center right) and the Armour and Swift complexes (center top) are visible in the photograph. The massive number of pens is spectacular. This was the stockyards at its largest. (Courtesy Mr. and Mrs. Hilton Kutch.)

Eighteen–wheelers unloaded due east of the Livestock Exchange Building for many years. The white building in the upper right-hand corner is the auction arena. It was constructed in 1960 in an attempt to compete with smaller country auctions draining away sales. Large stockyards all over the country took ideas from each other to try to bolster the dwindling market, but in the long run, they could not turn things around. (Courtesy Dalton Hoffman.)

Four

TRANSITIONS

For Fort Worth and the stockyards, the 1970s through the 1990s represented a tremendous time of transition. Doom and gloom permeated prognostications of the future economic outlook as the stockyards' livestock receipts shrank each year. From a high of over five million animals arriving at the yards in the World War II climate of 1944, receipts dropped to 1,844,793 only a decade later. In 1964, a decade after that, they dropped again to 705,382. By 1974, only 269,992 animals were arriving each year, and the total kept dwindling. The story was the same in other large markets. The mighty Chicago stockyards—reigning supreme in the industry for many years—closed in 1971. Denver closed the following year. Wichita closed in 1980.

Initial efforts were focused on keeping the Fort Worth Stockyards open. New York–based Canal-Randolph Corporation, who had ownership of the stockyards at the time, constructed an auction barn in 1960 and attracted attention through special stocker and feeder sales. After $2 million in federal funds were spent to improve flooding areas, Canal-Randolph completed a $750,000 project to restore the Livestock Exchange Building and modernize pens.

Meanwhile, North Side business leaders and the North Fort Worth Historical Society took measures to begin to attract tourists to the area. Volunteers kept a Visitor Center open in one corner of the coliseum. The North Fort Worth Historical Society planned a museum. If fewer cattle were going to arrive, why not invite people to view the historic district that had made Fort Worth what it was: "Cowtown," the "city where the West begins," as the local newspaper always claimed.

If storm clouds indicate trouble coming, stockyards watchers should have paid attention. In the late 1950s and early 1960s, livestock receipts dwindled. The two major meatpackers, who bought most of the slaughter animals that came to the stockyards, soon closed their doors, Armour in 1962 and Swift in 1971. Similar events were happening nationwide. By 1985, only 88,156 animals of all types arrived at the Fort Worth Stockyards for sale. (Courtesy Billy Joe Gabriel.)

Any one of the four corners of the North Main Street and Exchange Avenue intersection is one of the most famous street corners in Fort Worth. The photograph looks east at the Thannisch Building across the street, which has housed many businesses, starting with Thannisch's Stockyards Club back in 1906. The upstairs has always been a hotel. In the 21st century, it is the exclusive Stockyards Hotel. (Courtesy *Fort Worth Star-Telegram* Collection, Special Collections, the University of Texas at Arlington Library, Arlington, Texas.)

The Fort Worth Stockyards followed the lead of some of the other large stockyards in the nation and began an auction in 1959. The following year, they constructed this auction barn with comfortable stadium seating. The innovation of a live auction came as a way to compete with auctions that had developed in small, country towns in the 1930s and grew more popular in the 1940s and 1950s. (Photograph by J'Nell Pate.)

In the last half of the 20th century, to try to halt declining livestock receipts, large stockyards began holding auctions. Previously, all sales were by private treaty through commission agents. Beginning as only one day a week, Fort Worth's popular auction continued along with the private treaty sales. (Courtesy *Fort Worth Star-Telegram* Collection, Special Collections, the University of Texas at Arlington Library, Arlington, Texas.)

During auctions, an attendant would bring either one or a small group of animals into the ring through the door pictured here on the left. Bidding began once the announcer told the audience about the animals and who was selling them. After the sale, workers herded the animal or animals out the door to the right. (Courtesy *Fort Worth Star-Telegram* Collection, Special Collections, the University of Texas at Arlington Library, Arlington, Texas.)

William Pier, originally from South Dakota, once worked at the Stockyards National Bank in Omaha, Nebraska. He moved to Fort Worth in 1928 as vice president of the Stockyards National Bank in Fort Worth. Pier served as president of the Fort Worth Stockyards from 1959 to 1971. (Courtesy Charles Pier.)

John M. Lewis, previously president and general manager of the Sioux Falls Stockyards, came to Fort Worth in 1958 to replace Bill Pier when he retired the next year. Stockyards ownership told him he could employ new ideas and techniques to halt the decline in livestock receipts. While Lewis held the ownership's confidence, rank and file workers resisted the changes he tried to make. Unfortunately, because decline in the livestock industry was nationwide, his impact was limited. (Courtesy Mrs. John M. Lewis.)

This brick shell is all that remains of the Swift and Company meatpacking facilities. Two fires plagued the Swift building. A brief fire on January 11, 1974, involved only the fourth and fifth floors. A more disastrous fire began May 30, 1975, and burned all night. Because the fire extended into an underground tunnel, it was difficult to put out and smoldered for three weeks. (Courtesy Billy Joe Gabriel.)

Elmo A. Klingenberg, known as "Mo," replaced John M. Lewis as division president in 1971. Originally from Illinois, he hired on with United Stockyards there, and the company (which owned the Fort Worth Stockyards) sent him to Fort Worth in 1946. He remained and worked his way up to president. His retirement in 1982 was a factor in United allowing Gary Allen to create a new company to operate the stockyards. (Courtesy Elmo Klingenberg.)

The Fort Worth Stockyards was once the largest livestock market south of Kansas City, but the market was changing. When fewer livestock sales took place, fewer chutes were needed to unload or load livestock. The chutes were used less and less, and livestock receipts continued to dwindle. Eventually, a company called Superior Livestock Auction developed to sell cattle online and by video. Buyers picked up their cattle from chutes on ranches, not stockyards. (Courtesy Billy Joe Gabriel.)

Covered sheep pens on the south side of Exchange Avenue look awfully empty in this 1972 photograph. The heavy receipts of the 1940s—receipts that made Fort Worth the largest sheep market in the world—were long over. Stockyards Station, a popular restaurant and shopping area, is presently located on this spot after renovation occurred. (Courtesy *Fort Worth Star-Telegram* Collection, Special Collections, the University of Texas at Arlington Library, Arlington, Texas.)

In this photograph, the Livestock Exchange Building is visible beyond a lot full of debris. The scattered wood on the ground represents the remains of hog pens torn down after sales disintegrated. The Horse and Mule Barns still exist, however, and the sheep pens have been renovated into "Stockyards Station," where restaurants and shops abound. (Courtesy Tarrant County College District, Northeast Campus, Heritage Room, Fort Worth, Texas.)

In the 1960s and 1970s, as livestock were marketed in country auctions or feedlots, activity began to slow in stockyards all over the United States. On this day in November 1972, commission company owners and employees with offices in the Livestock Exchange Building gathered to watch television in their spare time. (Courtesy *Fort Worth Star-Telegram* Collection Special Collections, the University of Texas at Arlington Library, Arlington, Texas.)

Due to the change from stockyards to country auctions and feedlots, not nearly as many cattle or other livestock filled these historic pens in 1973 as in earlier years. Even with diminished receipts at the Fort Worth Stockyards, life went on. Though Armour and Swift were closed, a few independent meatpacking plants still purchased cattle for slaughter. (Courtesy *Fort Worth Star-Telegram* Collection, Special Collections, the University of Texas at Arlington Library, Arlington, Texas.)

During the late 1970s, as livestock receipts continued to decline, the Livestock Exchange Building sometimes became a lonely place. Here president Elmo Klingenberg checks the slow-moving market board on the wall behind reclining stockyards superintendent Paul Talles. (Courtesy *Fort Worth Star-Telegram* Collection, Special Collections, the University of Texas at Arlington Library, Arlington, Texas.)

In 1981, United Stockyards decided to allow the five remaining commission companies to take over the Fort Worth Stockyards and lease the stockyards facilities. Gary Allen, former owner of the Foley-Allen Commission Company, became president of the newly reorganized stockyards. The five companies dissolved and created one company they called Niles City Cattle Company d/b/a Fort Worth Stockyards. (Courtesy Mrs. Beverly Allen Cox, widow of Gary Allen; photograph by Lee Angle Photography, Inc.)

By the late 1980s, the Fort Worth Stockyards had hired some younger workers to herd animals down the alleys on motor scooters. Here in 1981, however, Leon Ralls—a fixture at the yard for several decades—does it the old fashioned way: driving cattle to the weigh scale, then herding them off to await their new owner from the livestock pens. This was the way Ralls knew. (Courtesy *Fort Worth Star-Telegram* Collection, Special Collections, the University of Texas at Arlington Library, Arlington, Texas.)

The *Fort Worth Star-Telegram* ran this photograph in March 1982 to show how empty the pens in the stockyards had actually become. The one visible cow looks terribly lonesome. Unfortunately, this became the situation more and more in the hundreds of pens stretching northward behind the coliseum, shown here. (Courtesy *Fort Worth Star-Telegram* Collection, Special Collections, the University of Texas at Arlington Library, Arlington, Texas.)

When L. White Boot and Saddle Shop on North Main Street went out of business, Leddy Boots purchased the neon boot sign for its own use. The boot now shines on the northwest corner of North Main Street and Exchange Avenue proclaiming "Leddy Boots." Next door to White's, Nona's Café fed the stockyards folks during the 1950s. It, too, is gone. (Courtesy Dalton Hoffman.)

Notice that this picture of West Exchange Avenue in the 1950s has a Stith's Jewelers on the northwest corner of North Main Street and Exchange Avenue. Leddy's had not yet expanded to the corner, nor acquired the big neon boot sign from White's. Except for the first block, most of East Exchange Avenue dealt with livestock activity in the 1950s, leaving West Exchange Avenue to provide most of the bars. In the 21st century, Exchange Avenue on both sides of Main Street caters to tourists. (Courtesy Dalton Hoffman.)

83

In 1941, three Leddy brothers came to the Fort Worth Stockyards to make boots. Later, they added saddles and Western wear. At one time, Leddy's ranked as the largest handmade boot and saddle company in the world. If everyone is not wearing boots in the stockyards today, perhaps they should be; boots and cattle once tread many a trail together throughout Texas, especially in Fort Worth. (Courtesy Leddy's Boots.)

In this 1950s photograph, the sign between Nocona Boots and the Right Hotel says, "Pool Pastime Club." The presence of a pool hall indicates that the stockyards area had become a bit rough and rundown. Ladies did not frequent the area with their husbands as they did their cattle business. It was a good time to visit downtown department stores instead, such as Leonard Brothers, Stripling's, Monnig's, and The Fair. (Courtesy Dalton Hoffman.)

The fellow driving these three white-faced steer blends in with the dirt and manure in the pen. In the early days, at the beginning of the 20th century, workers sometimes wore white shirts. This was no longer true. The stockyards represented a down-to-earth business; it was smelly and dirty. In fact, residents of North Fort Worth, many of whom worked in the stockyards or meatpacking plants, grew so accustomed to the aroma of the stockyards that they hardly noticed it. (Courtesy Dalton Hoffman.)

During the statewide sesquicentennial celebration, the 150th birthday of Texas, a wagon train traveled slowly around the Lone Star State. It began in early spring, traveling within 100 miles of each town so citizens could see the train and its participants. The train ended its travels on July 4, 1986, in the Fort Worth Stockyards, as seen in this photograph. (Courtesy Tarrant County College District, Northeast Campus, Heritage Room, Fort Worth, Texas.)

Charlie and Sue McCafferty were the "mother" and "father" of the North Fort Worth Historical Society. Charlie McCafferty helped create the historical society after he saw Niles City's historic city hall being demolished in 1976 for a parking lot. His wife, Sue, redheaded and determined, served as president. For many years, she fought the Fort Worth City Hall for grants and programs to save and renovate the stockyards area. (Courtesy McCafferty Family Archives.)

Back in the 1970s and 1980s, Charlie McCafferty, second from left in the hat, a retired fireman, took people on tours of the stockyards for free, just to be nice. His father had worked as a weigh master for many years for the Fort Worth Stockyards. Charlie has since passed away, but trained docents from the stockyards' visitors center now lead hour-long tours. (Courtesy *Fort Worth Star-Telegram* Collection, Special Collections, the University of Texas at Arlington Library, Arlington, Texas.)

A museum spearheaded by the North Fort Worth Historical Society opened in the Livestock Exchange Building in 1988. Enjoying themselves at the opening party are, from left to right, Steve Murrin, longtime stockyards business owner and future president of the Stockyards Preservation Foundation, and Willie Sears Jr. (Courtesy *Fort Worth Star-Telegram* Collection, Special Collections, the University of Texas at Arlington Library, Arlington, Texas.)

The "Bad Luck Wedding Dress" is on display in the North Fort Worth Historical Society Museum. The first bride who wore the dress married in 1886. The groom left in 1889 to seek gold in Oregon and never returned. Their daughter planned to wear it, but her groom died four days before the wedding on the way home from World War I. The original bride's granddaughter wore it as well, and her husband died a year after the wedding. In addition, a woman who only wore the dress for a historical home tour suffered a mysterious illness afterwards. (Photograph by J'Nell Pate.)

Ladies used stoves like this one early in the 20th century. The North Fort Worth Historical Society Museum features mostly Western items, including items having to do with the Fort Worth Stockyards. (Photograph by J'Nell Pate.)

A display in the museum honors the Cowboys Turtle Association (CTA), which was the original name of the Rodeo Cowboys Association. In March 1937, during the annual Southwestern Exposition and Fat Stock Show and Rodeo, the cowboys elected officers, and the CTA became the official organization to speak for the rodeo cowboys. The next year, they held their first annual convention in Fort Worth. A decade later, the organization became the Rodeo Cowboys Association. (Photograph by J'Nell Pate.)

This saddle exhibit in the North Fort Worth Historical Society Museum shows a lot of the equipment a cowboy needed on the trail, like a canteen, rope, saddlebags, and spurs. The museum is free and asks only for a small donation. Volunteers work to keep it open so that patrons can appreciate the tremendous historic heritage that the Fort Worth Stockyards National Historic District has bestowed upon the city of Fort Worth. (Photograph by J'Nell Pate.)

Located just half a block south of the famous intersection of North Main Street and Exchange Avenue is the now-empty New Isis movie theater. Louis Tidball, a North Fort Worth banker, took over a medicine show at the stockyards when the owner could not pay off a loan. A moving picture show in a tent was part of the show, so Tidball kept it going to try to get his money back. It did pretty well. In 1913, he constructed a building for the moving pictures, calling it the Isis Theater. When it burned in 1935, he rebuilt it and called the new theater, the New Isis. (Photograph by J'Nell Pate.)

Historical markers dot the landscape and sidewalks all over the Fort Worth Stockyards National Historic District. The Thannisch Building on the northeast corner of North Main Street and Exchange Avenue began as a small two-story Stockyards Club. In 1913, T. M. Thannisch tore the building down and constructed the three-story building shown in this picture. (Courtesy Stockyards Preservation Foundation.)

Five

BOOMING TIMES WITH TOURISTS

What early members of the North Fort Worth Historical Society only dreamed of in the late 1970s began coming true 20 years later: economic activity in the form of tourism began to replace the loss of economic activity in livestock at the Fort Worth Stockyards. Many things caused this success story. In 1981, a group of developers created the "world's largest honky-tonk" in Fort Worth's vacant exhibit building, constructed in 1936 for the fat stock show. The nightclub, named after developer Billy Bob Barnett, was called Billy Bob's Texas. Entrepreneurs like Holt Hickman, Joe Dulle, and Steve Murrin bought up or leased the city's empty buildings and created new businesses like the White Elephant Saloon and the Stockyards Championship Rodeo, held weekly in the newly renamed Cowtown Coliseum (formerly the North Side Coliseum). The city of Fort Worth, the North Fort Worth Business Association, and the North Fort Worth Historical Society cooperated on two seasonal celebrations: Chisholm Trail Days in June and Pioneer Days in the fall. A lot of local folks began coming out to the Fort Worth Stockyards for fun on these special weekends and, even more so, to hear well-known country western singers at Billy Bob's.

The Fort Worth Convention and Visitors Bureau helped attract folks to Fort Worth and urged tourists to visit not just the stockyards, but also the zoo, the city's many museums, and Six Flags Over Texas. Early in the 21st century, the bureau estimated that Fort Worth attracted one and a half to two million tourists a year with roughly half visiting the stockyards. As a result, the Fort Worth Stockyards is booming again, this time with happy two-legged arrivals.

In 1992, changing market conditions closed the Fort Worth Stockyards to livestock activity. Thanks to the efforts of the North Fort Worth Historical Society, the North Fort Worth Business Association (later the Fort Worth Stockyards Business Association), the city of Fort Worth, and many other people and businesses, after the storms came the rainbow. Thousands of visitors come each year to enjoy the Western atmosphere at many special events in the Fort Worth Stockyards. (Courtesy Billy Joe Gabriel.)

In 1977, the Fort Worth Chamber of Commerce created a Chisholm Trail Roundup to spark interest in redeveloping the stockyards. The event, renamed Chisholm Trail Days, became an annual celebration on the second weekend in June. Millions of Texas Longhorn cattle traveled up the Chisholm Trail through Fort Worth, actually bedding down north of downtown near the area that later became the stockyards. This crowded Exchange Avenue scene occurred during Chisholm Trail Days in 1983. Parking problems and other concerns caused Chisholm Trail Days to give way to many smaller events held more frequently in the stockyards. (Courtesy *Fort Worth Star-Telegram* Collection, Special Collections, the University of Texas at Arlington Library, Arlington, Texas.)

The Fort Worth Convention and Visitors Bureau has one office in downtown Fort Worth and two in busy tourist areas: one at the Will Rogers Center in West Fort Worth where the stock show is held each year, and the other in the Fort Worth Stockyards. The city constructed this building in the same style as the historic Livestock Exchange Building that opened in 1903. (Photograph by J'Nell Pate.)

One of the newest additions to the Fort Worth Stockyards National Historic District is the Hyatt Hotel, constructed in a beige stucco style to match the visitors center and the Livestock Exchange Building. Built early in the 21st century, the hotel itself is not historic, but located in front of the hotel is a bronze statue of Indian chief Quanah Parker with a historical marker that the Tarrant County Historical Commission dedicated in 2008. (Photograph by J'Nell Pate.)

This sign identifies Miss Molly's Bed and Breakfast on West Exchange Avenue in the Fort Worth Stockyards. (Photograph by J'Nell Pate.)

Miss Molly's began in 1910 on West Exchange Avenue as a bawdy house with Miss Molly as the madam. Today it is a popular bed and breakfast located just two blocks up the street within walking distance to everything in the stockyards. In this photograph, a life-size wooden figure of John Wayne stands guard at Molly's door. Miss Molly's establishment is testimony that, in the early days of the stockyards, wild and wooly things really did take place. (Photograph by J'Nell Pate.)

95

A hotel has existed in this building since 1907, although not always by the same name. The present name, Stockyards Hotel, came after a total renovation of the historic Thannisch Building at the famous corner of North Main Street and Exchange Avenue, the real entrance to the Fort Worth Stockyards Historic District. Rumor has it that famous 1930s bank robbers Bonnie and Clyde once had a room overlooking North Main Street. (Courtesy Stockyards Preservation Foundation.)

Special activities organized at the stockyards always try to include something for the kids. The presence of these goats is reminiscent of the days when all kinds of farm animals came to the stockyards at stock show time. Appealing to older youngsters is a wooden maze that stands due east of the Livestock Exchange Building where pens once held cattle. (Courtesy Stockyards Preservation Foundation.)

To a kid visiting the Fort Worth Stockyards, this is a steer that needs roping! Many of the special events that appear on weekends in the stockyards provide children's activities. Youngsters could even ride this bale of hay and not get bucked off. (Courtesy Stockyards Preservation Foundation.)

This is quite a change. Instead of horses and mules filling up Mule Alley between the two large barns, tourists have found extra places to park. While the two towers at the entrance to Mule Alley date from 1912, architectural copies are springing up throughout the stockyards. The newest towers frame the East Exchange Avenue entrance to Rodeo Plaza between Finchers' Western Wear and the Cowtown Coliseum. (Courtesy Billy Joe Gabriel.)

At the first of the 20th century, though livestock sales constituted the largest activity in Fort Worth, residents tried to ignore the animal smells; no one paid attention. Now, people get all excited and wait for nearly an hour on the curbs of East Exchange Avenue to see the twice-daily saunter of the Fort Worth Herd as they make their way down the street. Not much aroma accompanies them, but sometimes they leave a little "deposit" to show they came that way. (Courtesy Billy Joe Gabriel.)

Looking west on East Exchange Avenue, the white building is the old Stockyards National Bank, now Finchers' Western Wear. Just past Finchers' is the Stockyards Hotel, located on one of North Main Street and Exchange Avenue's four famous corners. When someone says, "Meet me at North Main and Exchange," one will know they'll be in the Fort Worth Stockyards. (Courtesy Billy Joe Gabriel.)

The Rodeo Shop, known for its bronzes, as well as other souvenir items, is located on the lower level of the Cowtown Coliseum. In the late 1970s, this space served as offices for the newly established North Fort Worth Historical Society, which began in 1976. Members volunteered in the office and answered questions from tourists who trickled in. (Courtesy Stockyards Preservation Foundation.)

Of course policemen who work the stockyards ride horseback! What else would they do in the most Western part of Fort Worth? (Photograph by J'Nell Pate.)

Texas hunters are familiar with "Deer Crossing" signs along the highways. It is logical, then, that "Cattle Crossing" signs appear in the Fort Worth Stockyards National Historic District. Twice a day, at 11:30 a.m. and 4:00 p.m., the "herd" of Texas Longhorns known as the Fort Worth Herd mosey down East Exchange Avenue to the delight of tourists—and any locals who happen to be around as well! (Courtesy Stockyards Preservation Foundation.)

This covered structure with red Thurber brick flooring was once a covered sheep pen. Over two million sheep arrived at the Fort Worth Stockyards in 1944, but receipts dwindled. The empty, refurbished (note the windows at left) sheep pens later became a part of the shops and restaurants of Stockyards Station. Tourists replaced sheep. The steam railroad train whose tracks pass through the building gave Stockyards Station its name. (Courtesy Billy Joe Gabriel.)

The Grapevine Vintage Railroad brings tourists to Stockyards Station, where restaurants and gift shops fill the aisles. When brought back into service toward the end of the 20th century, the line originally was called the Tarantula Train. The name came from a Fort Worth map, drawn in 1873, which inspired a Dallas newspaper to make fun of Fort Worth's aspirations to be a railroad center. Apparently, the many railroad lines converging on the city made Fort Worth and its proposed rail lines look like a tarantula. (Photograph by J'Nell Pate.)

The steam railroad needs to take on water during its stop in the stockyards. Then the engine turns around in the circular area north of the water tower, ready to go back the way it came: through Stockyards Station. This shopping area on the former site of covered sheep pens is called Stockyards Station because that is where the train makes its stop. (Photograph by J'Nell Pate.)

This white, three-story building presently houses Maverick Western Wear. The owners chose the name because the building, located on the southeast corner of North Main Street and Exchange Avenue, originally housed the Maverick Hotel. The dark area to the left in the picture was the entrance to the lobby. During a devastating flash flood on April 19, 1942, that drowned many yard animals, three dead mules washed up into the lobby of the Maverick Hotel. (Photograph by J'Nell Pate.)

This corner is East Exchange Avenue and Rodeo Plaza, which later acquired a new entrance to Rodeo Plaza. The Finchers' Western Wear building once housed the Stockyards National Bank. In the 1930s, bank robbers heard a motorcycle backfire, thought someone was shooting at them, and abandoned their robbery. To speed their getaway, they threw nails out the back window, causing flat tires to pursuers and others. (Courtesy Stockyards Preservation Foundation.)

This panorama of photographs graces the foyer of the Cowtown Coliseum, assembled in celebration of the coliseum's 100th birthday in 2008. The Fort Worth Stockyards Company constructed the coliseum in 1908 to house the Wild West shows that always accompanied the fat stock show. Rodeos still take place year round each Friday and Saturday night at the coliseum. (Courtesy Billy Joe Gabriel.)

H3 Ranch features steaks, ribs, and rainbow trout. Located on the northeast corner of the well-known intersection of North Main Street and Exchange Avenue, the restaurant is housed on the lower floor of the historic Thannisch Building, which also houses the Stockyards Hotel. The famous Cattlemen's Steak House is next door, making for mighty good eating in the Fort Worth Stockyards National Historic District. (Courtesy Stockyards Preservation Foundation.)

Barbecue was the food Polish immigrant Joe Riscky began serving in 1927, and his descendants still serve it in several locations. Jim Riscky owns three restaurants in the stockyards. At 120 East Exchange Avenue, he sells steaks where former owner Theo Yardanoff introduced calf fries. To make this item, Yardanoff acquired the male parts from bulls dismembered at the packing plants. Riscky keeps calf fries on the menu. (Courtesy Stockyards Preservation Foundation.)

Jesse Roach, who began business in the stockyards by selling insurance to cattle truckers, leased a building for his office. The space was a bit large for his needs, so in 1946, he started a little café. Thus began Cattlemen's famous steak house. He advertised nationally with, "Meet you at Cattlemen's in the Fort Worth Stockyards." (Courtesy Stockyards Preservation Foundation.)

An impressive art gallery in The Bull Ring ice cream shop is perhaps a surprise in the stockyards, but those who know about it, located at 112 East Exchange Avenue, go as much for the artwork as for the ice cream and drinks. Owner A. C. Cook features early Texas art from 1845 to 1965. (Courtesy Stockyards Preservation Foundation.)

Red Steagall is a nationally known Fort Worth country western singer and poet. Each year, the Fort Worth Stockyards features Red Steagall Days and hosts the Chuck Wagon Parade in his honor. Here tourists and locals view the parade in a historic spot, under the decades-old Fort Worth Stock Yards sign. (Courtesy Stockyards Preservation Foundation.)

Ever seen old St. Nick on a horse? One can see him around Christmastime on horseback in the annual Christmas parade at the Fort Worth Stockyards. In fact, one can see a lot of Santas. (Courtesy Stockyards Preservation Foundation.)

This entrance to the Texas Cowboy Hall of Fame was actually cut into the back of one of the two large Horse and Mule Barns constructed in 1912. Not only is it a hall of fame, it is also a museum that features, among other things, a large selection of wagons and carriages, including carriages for funeral homes, milk wagons, fire wagons, and other purposes. (Photograph by J'Nell Pate.)

In a big section of one of the Horse and Mule Barns is the Texas Cowboy Hall of Fame. Inducted cowboys include Walt Garrison, Larry Mahan, Buck Taylor, W. R. Watt Sr., and even the Light Crust Doughboys. (Courtesy Stockyards Preservation Foundation.)

Among the numerous special events held in the stockyards is the annual Texas Frontier Forts Muster each April. Fort Worth began in 1849 as an actual fort, and muster participants dress in uniforms soldiers would have worn back in the 19th century. These reenactors enjoy firing reproduction cannons similar to those used by the U.S. Army at the time. (Courtesy Billy Joe Gabriel.)

Crowds like these often congregate on weekends as a result of promoters planning special events to attract both local residents and tourists. Chevy Thunder Days 2008 took place in Stockyard Station's North Forty where, a few decades ago, cattle pens dominated the landscape. (Courtesy Stockyards Preservation Foundation.)

The Fort Worth Stockyards National Historic District home page is the official place to keep up with stockyards events. From its Cowtown Coliseum office, the foundation posts daily activities and attractions, as well as lodging options, where to dine, and where to shop on its Web site (www.fortworthstockyards.org). In contrast, years ago, stockyards workers acquired livestock prices daily from other major stockyards by telegraph and posted them on a chalkboard in the Livestock Exchange Building. (Courtesy Stockyards Preservation Foundation.)

Though the annual Southwestern Exposition and Livestock Show and Rodeo moved to the West Side of Fort Worth in 1944, Hub Baker, general manager of the Cowtown Coliseum, keeps the Stockyards Championship Rodeo booked every Friday and Saturday night. (Courtesy Billy Joe Gabriel.)

This young lady is a barrel racer. Her horse is trained to circle quickly around three different barrels in a modified clover-leaf pattern without turning one of them over. When they complete the pattern, the girl and her horse race to the coliseum entrance. If her time is faster than the other contestants, she wins. (Courtesy Stockyards Preservation Foundation.)

Bronc riding is one of the most popular rodeo activities. Fort Worth's Cowtown Coliseum, which hosted the first indoor rodeo in 1918, is unique in that the sport still appears each week. Businessmen who love Fort Worth and its Western image have made investments that allow Fort Worth to stay the "city where the West begins." (Courtesy Stockyards Preservation Foundation.)

Even though these cowboys await a bucking horse, this area is still called the "bull pen." The contestants in this photograph, wearing white hats and identifying numbers, help set up the next bronc ride at the Cowtown Coliseum on a Friday or Saturday night. (Courtesy Stockyards Preservation Foundation.)

Texans love to fly their flag. Remember, the Lone Star State was a separate country from 1836 to 1845. A Texas flag adjacent to a sign regaling the Fort Worth Stockyards presents an image that Fort Worth citizens find difficult to surpass. The flag is flying from the porch cover over the entrance to the exclusive Stockyards Hotel. (Courtesy Stockyards Preservation Foundation.)

XTO Energy, one of the major players in the Barnett Shale gas drilling in North Texas in the first part of the 21st century, purchased the old Swift and Company office building, which had remained vacant for several years. (Courtesy Billy Joe Gabriel.)

Although the Fort Worth Herd is accustomed to throngs of tourists lining Exchange Avenue twice a day, people along the sidelines should not get too close to those sharp horns. For safety, Fort Worth mandates a certain number of wranglers for the city-owned steer herd. The riders love to hang around and visit with tourists even after the herd goes back to the pens. It was Texas Longhorns coming through Fort Worth in the 1860s that began the long treks up the Chisholm Trail to those Kansas cow towns. (Courtesy Stockyards Preservation Foundation.)

Six

Just Folks

Sometimes very important people, and at other times, just plain old ordinary folks, shape the course of history. A lot more just watch others do big things and cheer. There is no way that this chapter can picture or mention all of the people who made the Fort Worth Stockyards the success it became, not once, but twice. The first success came early in the 20th century. Local businessmen worked for three decades to make it happen, bringing railroads, attracting meatpacking plants, and helping to develop a stockyards facility. Charles French's livestock clubs and the stock show, created to attract ranchers and their prize animals, played a part as well. Thousands of immigrants flocked to the United States early in the 20th century, and the thriving cattle industry attracted many to Fort Worth. The Fort Worth Stockyards became the largest market in the entire Southwest and ranked between third and fourth nationwide for over half a century.

The second success of the Fort Worth Stockyards, making it into a booming tourist attraction, came because local folks wanted it to happen. The North Fort Worth Historical Society, the North Fort Worth Business Association (later called the Fort Worth Stockyards Business Association), and the city of Fort Worth cooperated tremendously. Jim Wright, who was a congressman at the time and would later become the Speaker of the U.S. House of Representatives, helped get federal grants to improve the infrastructure of Fort Worth and attract businessmen to invest in renovation. Fortunately, many did.

This chapter shows a sampling of folks whose lives encountered the Fort Worth Stockyards at least once and some others who practically lived there.

The first name honored is not a person, but has been around longer than anybody else. Molly is the name of the bronze longhorn steer whose head and horns are featured on the front of the Livestock Exchange Building. Because of the Fort Worth Stockyards' importance to the economy, the city has adopted a longhorn steer logo on its stationery, vehicles, and other city property. (Courtesy Billy Joe Gabriel.)

These boys and girls represent the immigrants who came to Fort Worth, Texas, mainly in the first decade of the 20th century. These youngsters were members of Sokol, a Czechoslovakian organization, and were performing gymnastics in the coliseum. Many immigrants from Central and Eastern Europe came to the North Side of Fort Worth to work in the meatpacking plants and stockyards. Sokol was a patriotic organization created in the old country to keep young people strong. (Courtesy Fort Worth Museum of Science and History, Fort Worth Stock Show Collection.)

In the early days, it took a lot of stockyards workers to unload animals from the railroad cars, drive them to pens, feed and water them, drive them to be weighed, deliver them to new owners after purchase, and so on. All these activities took place in all types of weather from sunup until sundown—and sometimes a little longer than that. One old timer described it as "we worked from when you could [see] 'til you couldn't [see]." (Courtesy North Fort Worth Historical Society.)

Armour, Swift, and the stockyards workers each fielded a baseball team. Members of the Fort Worth Stockyards baseball team in this photograph on July 13, 1912, from left to right are (first row) unidentified, Lester Thannisch, Lee Allen, Lou Watson, Bunk Thetford, and Maurice Butz; (second row) Johnnie Bolinger, Harry Fifer, Claude Richards, and unidentified; (third row) Lefty Wright, Henry Klebold, Ward Farmer, Sammy Rogers, J. D. "Bus" Farmer, Raiford Ward, ? Taylor, and Katy Railroad manager Frank Ely. (Courtesy Jimmie Farmer.)

The Texas Agricultural and Mechanical College band performed an outdoor concert in either 1917 or 1918 in front of the Livestock Exchange Building. This performance may have been during the annual stock show. (Courtesy Fort Worth Museum of Science and History, Fort Worth Stock Show Collection.)

Elvis Presley came to Fort Worth in the fall of 1956 and sang at the North Side Coliseum. This photograph of the musician graces a historic panorama of photographs in the lobby of the coliseum. R. G. McElyea, coliseum manager, booked Elvis early in the year, before he became so famous, and promised $500 for the performance. By the time Presley and his band arrived, a record release had caused the musician's management to raise the asking price considerably, but McElyea held Elvis to the $500. Elvis was so upset, the story goes, that for 16 years he refused to perform in Fort Worth. (Courtesy Billy Joe Gabriel.)

Although it was not located in the stockyards (because the stockyards did not exist yet) the White Elephant was a real saloon in downtown Fort Worth during the cattle drive days. In the 1970s, Joe Dulle opened this presently popular nightspot by the same name in the stockyards. (Courtesy Stockyards Preservation Foundation.)

On February 8, 1887, a shootout took place in downtown Fort Worth between Jim Courtright and Luke Short, reenacted here in front of the White Elephant Saloon. In this photograph, Mike Googins (left) portrayed Courtright, and North Fort Worth Historical Society member and local lawyer Quentin McGown (right) took the Luke Short role. Short owned the original White Elephant Saloon. (Courtesy Billy Joe Gabriel.)

This sign stands outside the White Elephant Saloon to remind tourists of the next sidewalk gunfight. In the real shootout, Short killed Courtright, Fort Worth's city marshal. They are buried not far from each other in Oakwood Cemetery just northwest of downtown. (Courtesy Stockyards Preservation Foundation.)

The Brown Derby, located on North Main Street near the stockyards, opened in July 1986. Unfortunately, it lasted less than a year, closing April 15, 1987. The young man with suspenders at the far left end of the second row is Billy Joe Gabriel, who worked as a waiter during those months. In following years, Gabriel started a free newspaper called the *Stockyards Gazette* to promote the area. He later changed the name to the *Fort Worth Gazette*. (Courtesy Billy Joe Gabriel.)

This is the outside entrance of Billy Bob's Texas, located at the north end of the Fort Worth Stockyards complex. Billy Bob's opened in 1991, but the city of Fort Worth constructed the building in 1936 as an exhibit building for the annual stock show. (Courtesy Billy Joe Gabriel.)

Former Beatles drummer Ringo Starr seems to be calling his Billy Bob's appearance a "V" for victory. His visit to Billy Bob's testified to the club's ability to draw top performers. Early in the day, before performance preparations begin, stockyards tour guides let their customers take a peek inside the venue. (Courtesy Billy Joe Gabriel.)

Sonny Burgess, a local entertainer from Cleburne, Texas, plays his fiddle at Billy Bob's Texas, the largest honky-tonk in the world. Billy Bob's features country and western singers, for the most part, each Friday and Saturday night. Folks coming from out of town to the stockyards for a weekend could manage to see a performer at Billy Bob's one night and a rodeo at the Cowtown Coliseum the next. (Courtesy Billy Joe Gabriel.)

Local country singer Red Steagall, official cowboy poet of Texas, lives a few miles west of Fort Worth and makes numerous appearances at stockyards functions, including his Red Steagall Cowboy Gathering each October. An annual feature of this gathering is a wagon train that travels to the Fort Worth Stockyards from 50 miles away or more. Once it has arrived, festivities—including cowboy stories, singing, and poetry—can begin. (Courtesy Billy Joe Gabriel.)

Well-known celebrities Tommy Lee and Ludacris visited the rodeo at the Cowtown Coliseum one night and took part in the calf scramble. The performers' participation was filmed for *Battleground Earth*, their new show on the Discovery Channel. (Courtesy Stockyards Preservation Foundation.)

Among the folks who have appeared many times in the Fort Worth Stockyards is Willie Nelson. The cowboy folk singer has early ties to the stockyards area. His father worked at a service station on the North Side back in the 1940s. (Courtesy Billy Joe Gabriel.)

The Cowtown Opry is a nonprofit organization dedicated to the preservation, performance, and promotion of Texas heritage music. Of course, the Fort Worth Stockyards would be headquarters. The organization brings Western music shows free to the public every Sunday from 2:00 to 3:00 p.m. on the steps of the Livestock Exchange Building. (Courtesy Stockyards Preservation Foundation.)

Trevor Brazile was inducted into the Texas Cowboy Hall of Fame in January 2008. He has won the honor of Champion All Around Cowboy, as well as awards for timed steer roping. He hails from Decatur, Texas. (Courtesy Billy Joe Gabriel.)

Pictured here are the key investors in the modern Fort Worth Stockyards National Historic District. From left to right are Fort Worth Stockyards developer Holt Hickman, who owns the Livestock Exchange Building and a portion of Billy Bob's Texas; Billy Minick, general manager and partial owner of Billy Bob's Texas; Steve Murrin, Stockyards Preservation Foundation president and partial owner of Billy Bob's Texas; Hub Baker, general manager of the Cowtown Coliseum; and Don Jury, also partial owner of Billy Bob's Texas. (Courtesy Stockyards Preservation Foundation.)

Joe Dulle, Gene Miller, and Jane Schlansker, from left to right, were the incorporators of White Elephant Enterprises, Inc., which, beginning in the 1970s, operated nearly one dozen businesses in the Fort Worth Stockyards National Historic District. Dulle served as president. Their involvement and that of their investors played a major role in the redevelopment success of the area in the ensuing decades. They posed in front of the White Elephant Saloon when it opened in 1976. (Courtesy Joe Dulle.)

Kristin Liggett served in 2008 as president of the Fort Worth Stockyards Business Association. Here she is dressed for her other role. Liggett is the trail boss for the Fort Worth Herd, the popular group of Texas Longhorn cattle that trail along East Exchange Avenue for the benefit of tourists at 11:30 a.m. and 4:00 p.m. each day. (Courtesy Stockyards Preservation Foundation.)

In the early spring of 2008, while campaigning before the Texas primary for the Democratic presidential nomination, Hillary Rodham Clinton spoke to a large crowd at the Fort Worth Stockyards. She was following the example of Theodore Roosevelt and Jimmy Carter, who also spoke in the stockyards. Ronald Reagan came to the North Side of Fort Worth, but he spoke at Meacham Field, a couple of miles farther north on North Main Street. (Courtesy Stockyards Preservation Foundation.)

Folks who know him well call Steve Murrin "Cowboy" because he always looks the part. No matter where he goes, Murrin wears jeans, boots, a 10-gallon white hat, red bandana, and handlebar mustache. Successful stockyards development owes a great deal to hometown boy Steve Murrin. This Western image of Murrin and his horse, Matt Dillon, are a fitting conclusion to this photographic journey through the history of the Fort Worth Stockyards. (Courtesy Stockyards Preservation Foundation.)

Across America, People are Discovering
Something Wonderful. *Their Heritage.*

Arcadia Publishing is the leading local history publisher in the United States. With more than 4,000 titles in print and hundreds of new titles released every year, Arcadia has extensive specialized experience chronicling the history of communities and celebrating America's hidden stories, bringing to life the people, places, and events from the past. To discover the history of other communities across the nation, please visit:

www.arcadiapublishing.com

Customized search tools allow you to find regional history books about the town where you grew up, the cities where your friends and family live, the town where your parents met, or even that retirement spot you've been dreaming about.